WADDINGTON GALLERIES – SCHIRMER/MOSEL

AFTER MIDNIGHT **AXEL HÜTTE**

ATLANTA

CHICAGO

LAS VEGAS

LOS ANGELES

NEW YORK

MIAMI

HOUSTON

MINNEAPOLIS

DALLAS

SEATTLE

ONCE UPON A TIME ... IN AMERICA

ES WAR EINMAL ... IN AMERIKA

MARTIN FILLER

It is an acceptable stretch of historical truth to say that the first subject of photography was the city. The recent emergence of an 1825 heliograph by Joseph Nicéphore Niépce, made from an engraving, has usurped his celebrated (if hazy) *View from the Window at Le Gras*, circa 1826, long considered the earliest man-made photographic image. And even though that rooftop view of a village in Burgundy was doubtless prompted more by expediency than choice, it is indisputable that during the first decades of the medium, urban and architectural themes ranked second in frequency only to portraiture.

There were, of course, strong commercial imperatives favoring both initial foci of the Daguerrean art (as it became known after Niépce's death, in 1833, which left the field to his less inventive business partner, Louis Jacques Mandé Daguerre). The desire to record one's visage for posterity has been a prime motivation for art since time immemorial (outnumbered perhaps only by images for religious veneration). Yet the visual documentation of civic monuments remained a privilege of the aristocracy until the advent of those parallel bourgeois phenomena of the mid-nineteenth century: mass travel made possible by the railroad, and the democratization of souvenir views previously attainable only as costlier paintings, drawings, or prints.

Although most early photographic views of buildings or cities were of mainly topographical interest, others – including the work of Roger Fenton in England and Henri Le Secq in France during the 1850s – rose to the level of art. With that higher degree of accomplishment came a growing awareness among such photographers that the technical limitations of their medium mitigated against a convincing evocation of cities when observed from any distance beyond close range.

By the 1860s, photographers began creating panoramic views by rotating their cameras to capture a lateral sequence and joining the prints to approximate the effect of 360-degree paintings that had been a familiar component of European popular culture since the Napoleonic Age. Those continuous canvases gave a lifelike impression of the period's great battles to an urban audience lucky enough to have missed the horrors of war but fascinated by this new, vicarious experience. But the new pieced-together photographs could never approach the sense of full immersion simulated by the monumental scale and all-encompassing surround of those spectacular peintures panoramiques.

In general, architectural subject matter waned in importance by the turn of the twentieth century, when a concerted effort to legitimize photography as an art form favored themes from nature, conveyed in a painterly manner by such Pictorialist photographers as Alfred Stieglitz, Edward Steichen, and Getrude Kasebier. The great resurgence of

Man muß die historische Wahrheit nicht allzusehr zurechtbiegen, wenn man sagt, daß das erste Thema der Photographie die Stadt war – auch wenn eine vor kurzem entdeckte, 1825 von Joseph Nicéphore Niépce nach einer Radierung aufgenommene Heliographie dessen berühmten (wenn auch verschwommenen) *Blick aus dem Fenster von Le Gras*, ca. 1826, entthronte, der bis dahin als älteste bekannte Photographie galt; und selbst dieser Blick über die Dächer eines burgundischen Dorfes ist zweifellos eher seiner zufälligen Verfügbarkeit zu verdanken als einer bewußten Auswahl. Doch fest steht, daß in den ersten Jahrzehnten des Mediums nur die Portraitphotographie die Aufnahmen städtischer oder architektonischer Szenen an Häufigkeit noch übertraf.

Natürlich spielten starke kommerzielle Motive ihre Rolle bei diesen beiden frühen Schwerpunkten der Daguerreotypie (wie sie nach Niépces Tod im Jahre 1833 hieß, als sein weniger erfinderischer, doch geschäftstüchtiger Partner Louis Jacques Mandé Daguerre übernahm). Der Wunsch, die eigenen Gesichtszüge für die Nachwelt festzuhalten, ist neben der frommen Andacht seit Urzeiten ein Hauptantrieb der Kunst gewesen. Die Dokumentation weltlicher Bauwerke blieb hingegen ein Privileg der Oberschicht – das änderte sich erst mit den beiden sich gegenseitig beflügelnden bürgerlichen Errungenschaften aus der Mitte des neunzehnten Jahrhunderts, der Eisenbahn, die das Reisen für weite Kreise erschwinglich machte, und der technischen Verbreitung von Bildern, die vorher nur als teure Gemälde, Zeichnungen oder Drucke zu haben waren.

Die meisten frühen Photographien von Gebäuden oder Stadtansichten entstanden hauptsächlich zu topographischen Zwecken, andere – darunter die Arbeiten von Roger Fenton in England und Henri Le Secq in Frankreich in den 1850er Jahren – hatten künstlerische Qualitäten. Mit dem künstlerischen Sinn entwickelten diese Photographen auch ein stärkeres Bewußtsein dafür, daß wegen der technischen Grenzen ihres Mediums Darstellungen von Städten nur in kürzerer Perspektive wirklich überzeugten.

Als die 1860er Jahre kamen, schufen die Photographen ihre ersten Panorama-Ansichten, indem sie die Kamera um die Achse des Stativs drehten und eine Längsfolge von Aufnahmen machten, eine Nachahmung der seit napoleonischer Zeit in der populären europäischen Kultur weit verbreiteten gemalten Panoramen. Diese 360°-Leinwände vermittelten einem städtischen Publikum, das zu seinem Glück nicht selbst dabei gewesen war, einen lebensechten Eindruck von den großen Schlachten der Epoche – eine neuartige, erregende Erfahrung. Aber die zusammengesetzten Photographien konnten nicht annähernd das Erlebnis des vollständigen Eintauchens schaffen, das den spektakulären und monumentalen *peintures panoramiques* gelang.

Insgesamt verloren architektonische Themen an der Wende zum

photographic interest in the city occurred only with the burgeoning recognition of the new architecture – and specifically American high-rise construction – as an emblematic feature of emergent modernism.

A breakthrough in the artistic reconsideration of architecture as photographic subject came with Stieglitz's atmospheric images of New York's Flatiron Building in 1903, which erased any doubts that a cityscape can have as much aesthetic validity as any rural landscape. As modernism began to assert itself in all mediums, but most visibly in public architecture, the Romantic aspects of Stieglitz's manner – so dependent on nuances of changing weather and natural light – came to seem outdated. His Pictorialism was superseded by a forthright, "objective" approach, free of references to past styles, and therefore considered appropriate to the "scientific" values of Purist architecture. The growth of architectural photography as an adjunct to publicity in the proliferating professional journals in turn led to a greater differentiation between pictures taken with the express purpose of documenting a building, and art photography that used architecture as its premise, but was not primarily concerned with the detailed depiction of a structure.

A few photographers bridged that gap effortlessly, most notably Berenice Abbott, whose systematic documentation of New York City between 1935 and 1939 for the Federal Arts Project (one of several U.S. government-funded programs to keep artists gainfully employed during the Great Depression) was much like the Paris photographs of Eugène Atget earlier in the century. Both extraordinary, comprehensive bodies of work captured a crucial transitional phase as vestiges of earlier development gave way to the familiar forms of those cities as we now know them.

The recent resurgence of the city as a major theme in art photography is primarily attributable to a group of German photographers born during their still-divided country's first post-World War II decade. Given their shared nationality and proximity in age, Axel Hütte (born in Essen, 1951), Thomas Struth (Geldern, 1954), Andreas Gursky (Leipzig, 1955), and Thomas Ruff (Zell am Harmersbach, 1958) seem fated to be grouped as a school or movement, despite significant differences beyond their favoring large-format color prints.

Why this urban matter has come so strongly to the fore at this particular moment is not difficult to fathom, and these fifty-something Germans are hardly the only photographers drawn to imagery that equates large-scale urbanism with forces of globalization and consumerism. For example, Robert Polidori (born the same year as Hütte) has developed a specialty in chilling vistas of bizarre new cityscapes from Dubai to Shanghai, places so devoid of recognizable civic references (even in

zwanzigsten Jahrhundert an Bedeutung; je mehr es darum ging, Photographie als Kunstform zu etablieren, desto mehr rückten Themen aus der Natur, die Photographen wie Alfred Stieglitz, Edward Steichen und Gertrude Käsebier in malerischer Manier präsentierten, in den Vordergrund. Die Gegenbewegung setzte erst mit dem großen Erfolg der modernen Architektur ein, als die Photographen insbesondere in den amerikanischen Wolkenkratzern Symbole der neuen Zeit erkannten.

Ein Durchbruch in der künstlerischen photographischen Darstellung von Architektur kam mit Stieglitz' atmosphärischen Bildern des New Yorker Flatiron Building, 1903 – Aufnahmen, die endgültig alle Zweifel daran vertrieben, daß eine Stadtansicht ein künstlerisch genauso lohnendes Motiv sein konnte wie jede Landschaft. Als die Moderne sich in allen Lebensbereichen durchzusetzen begann – am augenfälligsten an öffentlichen Bauwerken –, wirkten die romantischen Elemente an Stieglitz' Manier, die soviel den feinen Nuancen in Wetter und Licht verdankte, zunehmend veraltet. Sein Piktorialismus wurde verdrängt durch einen geradlinigen, »objektiven« Ansatz ohne jede Verbeugung vor älteren Stilen, der besser zur »Wissenschaftlichkeit« einer puristischen Architektur zu passen schien. Der Aufstieg der Architekturphotographie durch die immer zahlreicher werdenden Fachzeitschriften führte wiederum zu einer größeren Differenzierung zwischen Bildern, die ausdrücklich dazu aufgenommen waren, Bauwerke zu dokumentieren, und künstlerischer Photographie, die Bauten als Sujet nahm, aber nicht in erster Linie auf die Darstellung der Struktur in allen Einzelheiten aus war.

Einige wenige Photographen überbrückten diese Kluft, allen voran Berenice Abbott, deren 1935–39 für das Federal Arts Project entstandene Bestandsaufnahme der New Yorker Architektur – eines von mehreren staatlichen Programmen in den USA der Wirtschaftskrise, mit denen Künstlern Arbeit verschafft wurde – viel Ähnlichkeit mit den Paris-Bildern Eugène Atgets vom Anfang des Jahrhunderts hatte. Beide hielten in ihren umfassenden, herausragenden Serien eine wichtige Umbruchsphase fest, in der die letzten Reste älterer Bebauung der Stadt Platz machten, wie wir sie heute kennen.

Daß in jüngster Zeit Städte als Thema der Photographie wieder an Bedeutung gewinnen, verdanken wir in erster Linie einer Reihe von Photographen, die im geteilten Deutschland des ersten Nachkriegsjahrzehnts zur Welt kamen. Da Herkunft und Alter sie verbinden, wird es Axel Hütte (geboren in Essen, 1951), Thomas Struth (Geldern, 1954), Andreas Gursky (Leipzig, 1955) und Thomas Ruff (Zell am Harmersbach, 1958) wohl nicht erspart bleiben, daß man sie als Schule oder Bewegung sieht, obwohl es jenseits der gemeinsamen Vorliebe für Farbe und für große Formate bedeutende Unterschiede zwischen ihnen gibt.

terms of their own cultures) that Hütte's recent photographs of American cities make those places seem almost classically ordered in contrast.

The evenness of tone among Hütte's nocturnal American cityscapes has much to do with the fact that for the past half century those metropolises have become so architecturally homogenous that it is sometimes difficult for the frequent traveler to determine which city he is in, as has happened to me more than once in the Midwest. (One exception is Dallas, where the owners of tall buildings took to the notion of outlining their structures with rows of lights, giving them an oddly schematic feeling quite the opposite of the volumetric quality conveyed by traditional nighttime spotlighting.)

The civic values of Houston and Minneapolis could not be more different, but extremes of climate in both locales have resulted in enclosed downtown pedestrian systems – tunnels to escape Texas' withering summer heat and "skyways" to escape Minnesota's brutal winter cold. Those internalized circulation networks give the streets of those downtown districts a depopulated feel even during the workday in fine weather.

The centers of other American cities Hütte has visited – including Atlanta, Los Angeles, and Saint Louis – are virtually deserted after business hours. That eerie vacantness is symptomatic of the suburban sprawl that has sucked the nightlife out of once vibrant neighborhoods, and has gone virtually unchecked despite being an avowed concern of Americans in public opinion polls.

Two of the most walker-friendly American cities are New York (where the fastest way to move around midtown Manhattan is often on foot) and Las Vegas (where ambling up and down the Vegas Strip has become a ritual for Americans who barely get out of their SUVs and minivans back home). Another is New Orleans, the demise of which, exacerbated by governmental neglect in the aftermath of Hurricane Katrina in 2005, will unquestionably be seen as more of a man-made than natural disaster, and of unprecedented proportions in America once the long-term economic impact is felt.

That the skyscraper has been America's quintessential contribution to modern architecture was not lost on the destroyers of the World Trade Center. Although the terrible loss of human life there was far less than it might have been thanks to the twin towers' not collapsing immediately upon the attack, there could not have been a more symbolic assault on American power. The United States' skylines – and that of New York in particular – have looked far less invincible since September 11, 2001, and it is difficult to consider Hütte's photographs of American cities since 2002 without that thought surfacing time and again.

Yet the tone of his ongoing series is anything but elegiac. At times

Warum städtische Motive gerade jetzt wieder so sehr ins Blickfeld kommen, ist leicht erklärt, und diese deutschen Photographen um die Fünfzig sind bei weitem nicht die einzigen, die in ihren Bildern monumentalen Urbanismus mit den Kräften von Globalisierung und Kapitalismus gleichsetzen. Zum Beispiel zeigt Robert Polidori (geboren im selben Jahr wie Hütte) ein Faible für einschüchternd-bizarre neue Stadtlandschaften von Dubai bis Shanghai, Orte, denen so sehr jede Spur einer gesellschaftlichen Ordnung fehlt (selbst in ihrer eigenen Kultur), daß die amerikanischen Städte in Hüttes jüngsten Aufnahmen im Vergleich dazu geradezu wohlgeordnet wirken.

Die Gleichmäßigkeit des Tons bei Hüttes Nachtansichten amerikanischer Städte hat viel damit zu tun, daß die Metropolen in den letzten fünfzig Jahren in ihrer Architektur so austauchbar geworden sind, daß es jemandem, der viel unterwegs ist, oft nicht leichtfällt zu sagen, wo er sich gerade befindet; mir ist das im mittleren Westen mehr als einmal so ergangen. (Eine Ausnahme ist Dallas, wo es sich eingebürgert hat, bei Hochhäusern die Umrisse zu beleuchten, was einen merkwürdig zweidimensionalen Eindruck ergibt, ganz anders als die übliche nächtliche Anstrahlung, die eher die Raumtiefe betont.)

Houston und Minneapolis könnten in ihrer Grundstimmung nicht unterschiedlicher sein, doch extreme Klimaverhältnisse haben an beiden Orten zu geschlossenen Systemen von innerstädtischen Fußgängerwegen geführt, in Houston zu den Tunneln, mit denen man der sengenden Sommerhitze entgeht, und zu den »Skyways« hoch in der Luft, die vor der klirrenden Kälte des Winters in Minneapolis schützen. In beiden Fällen läßt das geschlossene System die Innenstadt entvölkert erscheinen, selbst werktags und bei gutem Wetter.

Die Zentren anderer amerikanischer Großstädte, die Hütte besucht hat – darunter Atlanta, Los Angeles und Saint Louis –, sind nach Büroschluß regelrecht verlassen. Diese gespenstische Leere ist eine Folge des immer weiteren Ausuferns der Vorstädte, das den einst lebendigen Innenstadtvierteln alles nächtliche Leben aussaugt und das unvermindert weitergeht, auch wenn Amerikaner in Meinungsumfragen regelmäßig ihre Besorgnis darüber zum Ausdruck bringen. Zu den fußgängerfreundlichsten Städten der USA gehören New York (wo man in Manhattan zu Fuß oft schneller vorankommt als mit jedem Verkehrsmittel) und Las Vegas (wo das Promenieren auf dem Vegas Strip zu einem Ritual für Amerikaner geworden ist, die zu Hause nur selten ihre Trucks und Minivans verlassen). Eine weitere ist New Orleans, eine Stadt, deren Untergang, beschleunigt durch mangelnde amtliche Hilfe nach dem Hurrikan Katrina im Jahr 2005, die Zukunft gewiß eher als von Menschen verursachte denn als Naturkatastrophe sehen wird, und zwar als eine von ungeahnten Ausmaßen,

Hütte can be playfully deadpan, especially in his views of Las Vegas. Admirably, he steers clear of the gambling resort's purposeful vulgarity, which can make any six-year-old with a disposable camera seem like a social commentator. Rather than overloading our eyes with the gaudy excesses of the Strip, Hütte shoots the brightly illuminated main drag of Vegas from so far away that it zips across the entire width of a movie-screen-like print like, well, a strip.

Hütte also takes aim at the recent Vegas vogue for replicating far-away places – a bogus Venice here, a pseudo Paris there. One droll but damning composition shows the New York New York hotel's pathetic simulacrum of that most enchanting of all American skyscrapers, the Chrysler Building, abutting an inept approximation of Mies van der Rohe's sublime Seagram Building. The botched proportions of the sham Seagram provide an unintentional object lesson in how the International Style was debased by developers more interested in eliminating costly details than in attaining reductivist perfection.

It is not difficult to imagine that in ten or twenty years this series will be viewed as something of a commentary on the state of the United States at a dangerous – and perhaps irreversible – turning point in its history. Sheer size has tended to signify importance in American life – as well as in American painting and sculpture – since the mid-nineteenth century. But the principle that bigger is better has become much more pronounced since World War II, from which America emerged as the mightiest world power. Hütte and his German contemporaries have seized upon the Abstract Expressionists' colossal format with an effectiveness equal to the New York School, and, especially in the case of Hütte's American city views, it puts across an impression of magnitude appropriate to subject and place.

Furthermore, Hütte's use of Duratrans adds a mysterious sense of depth that stops short of holographic gimmickry, but nonetheless is far more intriguing than conventional color prints. Duratrans is a transparent material, similar to slide film, onto which the photograph is printed. Hütte was inspired to use this unusual method because of his fascination with the Daguerreotype – a silver plate on which the photographic image fades away or stands out more clearly, depending on the angle from which it is viewed. His use of Duratrans achieves a similar effect as the light travels through the film and onto a surface that reflects it back in places. The result is a subtle change in intensity of light, giving an uncanny depth to these dark nighttime images of illuminated cities as the viewer moves in front of the works.

Will these haunting panoramas speak to future generations as penetrating commentaries on the corporate dominance of America, the self-

wenn die langfristigen wirtschaftlichen Auswirkungen erst einmal spürbar werden.

Daß der Wolkenkratzer der entscheidende amerikanische Beitrag zur modernen Architektur ist, war den Zerstörern des World Trade Center nicht entgangen. Zwar hat der Anschlag nicht so viele Menschenleben gekostet, wie zu befürchten gewesen wäre, weil die Türme nicht gleich einstürzten, aber trotzdem hätte man sich einen symbolischeren Angriff auf die Macht der USA gar nicht vorstellen können. Die Skylines der Vereinigten Staaten – und ganz besonders diejenige von New York – sehen heute weit weniger unverletzlich aus als vor dem 11. September 2001, und man tut sich schwer, Hüttes seit dem Jahr 2002 entstandenen Aufnahmen amerikanischer Städte anzusehen, ohne daß einem dieser Gedanke dabei von Zeit zu Zeit kommt.

Doch der Tonfall dieser noch nicht abgeschlossenen Serie ist alles andere als elegisch. Bisweilen setzt Hütte das schönste Pokerface auf, gerade in seinen Aufnahmen aus Las Vegas. Er hält guten Abstand von der kalkulierten Vulgarität der Spielhöllen, wo jeder Sechsjährige mit Einwegkamera eine gesellschaftskritische Reportage machen könnte. Er überfüttert unsere Augen nicht mit den bunten Exzessen des Strip, sondern nimmt diese hell erleuchtete Hauptschlagader von Vegas aus so großer Entfernung auf, daß sie sich über die ganze Breite des filmleinwandgroßen Abzugs zieht – ein Streifen eben.

Hütte knöpft sich auch die neueste Vegas-Mode vor, die Repliken anderer Orte – ein falsches Venedig hier, ein Pseudo-Paris dort. Eine komische, dabei vernichtende Komposition zeigt die im »New York New York«-Hotel zu findende jämmerliche Nachbildung des amerikanischsten aller Wolkenkratzer, des Chrysler Building, Seite an Seite mit einem stümperhaften Modell von Mies van der Rohes großartigem Seagram-Hochhaus. Die verzerrten Proportionen des falschen Seagram führen uns in einer unfreiwilligen Lektion vor Augen, wie der Internationale Stil von Bauherren und Bauunternehmern korrumpiert wurde, denen immer eher daran gelegen war, teure Details einzusparen, als durch Reduktion Vollkommenheit zu erlangen.

Man kann sich gut vorstellen, daß diese Serie in zehn oder zwanzig Jahren als eine Art Kommentar zum Zustand der Vereinigten Staaten an einem kritischen Punkt in der Geschichte des Landes gesehen wird – einem Wendepunkt, von dem es vielleicht kein Zurück mehr gibt. Schiere Größe hat im amerikanischen Leben seit Mitte des neunzehnten Jahrhunderts stets für Bedeutung gestanden, auch in der amerikanischen Malerei und Bildhauerei. Aber seit dem Zweiten Weltkrieg, aus dem die Vereinigten Staaten als mächtigste Weltmacht hervorgingen, drängt sich das Prinzip des »Je größer desto besser« noch mehr in den Vordergrund. Hütte und

styled "indispensable nation," during the Age of Bush? I suspect they will, although Americans are characteristically resistant to accepting critiques from foreigners, to say nothing of their fellow countrymen. That is one reason why they were among the last – long after the Germans and Italians – to understand the central importance of Andy Warhol, as they smiled at his soup cans and flowers and ignored his race riots and electric chairs. What is most impressive about Hütte is his restraint, which gives the best of his post-millennial American cityscapes their disturbing power.

Dorothea Lange, whose photography was overtly political in its unsparing exposure of social injustice in Depression Era America, remarked that "the camera is an instrument that teaches people how to see without a camera." Although Hütte's dark vision of present-day America is not overtly political, his Warholian tactic of holding up a mirror to society is tellingly reflective. However Hütte's cumulative portrait of a nation at a crucial juncture in its history will be interpreted in the long view, it is worth recalling that his fatherland not long ago believed it, too, could bestride the world.

seine deutschen Generationsgenossen haben sich das Kolossalformat der Abstrakten Expressionisten zu eigen gemacht, und die Ergebnisse können es mit den Werken der New York School aufnehmen – diese Bilder vermitteln eine Größe, die dem Ort und dem Thema angemessen ist.

Außerdem fügt Hüttes Verwendung von Duratrans-Folie einen geheimnisvollen Eindruck von Tiefe hinzu; keine holographische Zirkusnummer, aber doch weitaus eindrucksvoller als konventionelle Farbabzüge. Duratrans ist ein transparentes Material, ähnlich wie Diafilm, auf dem das Bild abgezogen wird. Hütte ist auf dieses unkonventionelle Verfahren aus Interesse an der Daguerreotypie gekommen, auf deren Silberplatte das Bild blasser wird oder deutlicher hervortritt, je nachdem, aus welchem Winkel man es betrachtet. Mit Duratrans läßt sich ein ähnlicher Effekt erzielen, denn das Licht scheint durch den Film auf eine Oberfläche, die es teilweise reflektiert. So ergeben sich leichte Variationen in der Intensität des Lichts, die diesen dunklen Nachtaufnahmen erleuchteter Städte eine geheimnisvolle Tiefe geben, wenn man sich vor dem Bild bewegt.

Werden diese ausdrucksvollen Panoramen zukünftigen Betrachtern als hellsichtiger Kommentar zu einem von der Industriemacht beherrschten Amerika, der nach eigenen Begriffen »unverzichtbaren Nation«, in der Ära Bush vorkommen? Ich fürchte ja, auch wenn Amerikaner Kritik von Ausländern so gut wie nie zur Kenntnis nehmen, und von ihren eigenen Landsleuten erst recht nicht. Deshalb waren sie auch unter den letzten, die – lange nach den Deutschen und Italienern – die zentrale Bedeutung von Andy Warhol erkannten; sie lächelten über seine Suppendosen und bunten Blumen und ignorierten die Rassenkrawalle und elektrischen Stühle. Das Eindrucksvollste an Hütte ist seine Zurückhaltung, aus der die besten seiner Stadtansichten vom Amerika nach der Jahrtausendwende ihre verstörende Kraft beziehen.

Dorothea Lange, deren Arbeiten unverblümt politisch waren – gnadenlos in ihrer Bloßstellung der sozialen Ungerechtigkeiten im Amerika der Depressionszeit –, sagte: »Die Kamera ist ein Instrument, das den Leuten beibringt, wie man ohne Kamera sieht.« So offen politisch sind Hüttes düstere Visionen vom Amerika unserer Tage nicht, doch die Warholsche Art, wie er der Gesellschaft einen Spiegel vorhält, ist umso entlarvender. Und wie immer man Hüttes Portrait einer Nation an einem kritischen Punkt ihrer Geschichte auf lange Sicht verstehen wird – man tut gut daran nicht zu vergessen, daß auch sein Vaterland, und vor gar nicht langer Zeit, sich einmal zum Herrn der Welt aufschwingen wollte.

Übersetzung: Manfred Allié.

Martin Filler is a longtime contributor to The New York Review of Books, which in Spring 2007 will publish an anthology of his essays, Makers of Modern Architecture, to be distributed by Random House. He has written on photography for The New York Times, Vanity Fair, and Departures, and is a fellow of The American Academy of Arts and Sciences.

Martin Filler schreibt seit vielen Jahren Beiträge für die New York Review of Books, die im Frühjahr 2007 unter dem Titel Makers of Modern Architecture eine Anthologie seiner Aufsätze herausgeben wird (Random House). Er hat für die New York Times, Vanity Fair und für Departures über Photographie geschrieben und ist Mitglied der American Academy of Arts and Sciences.

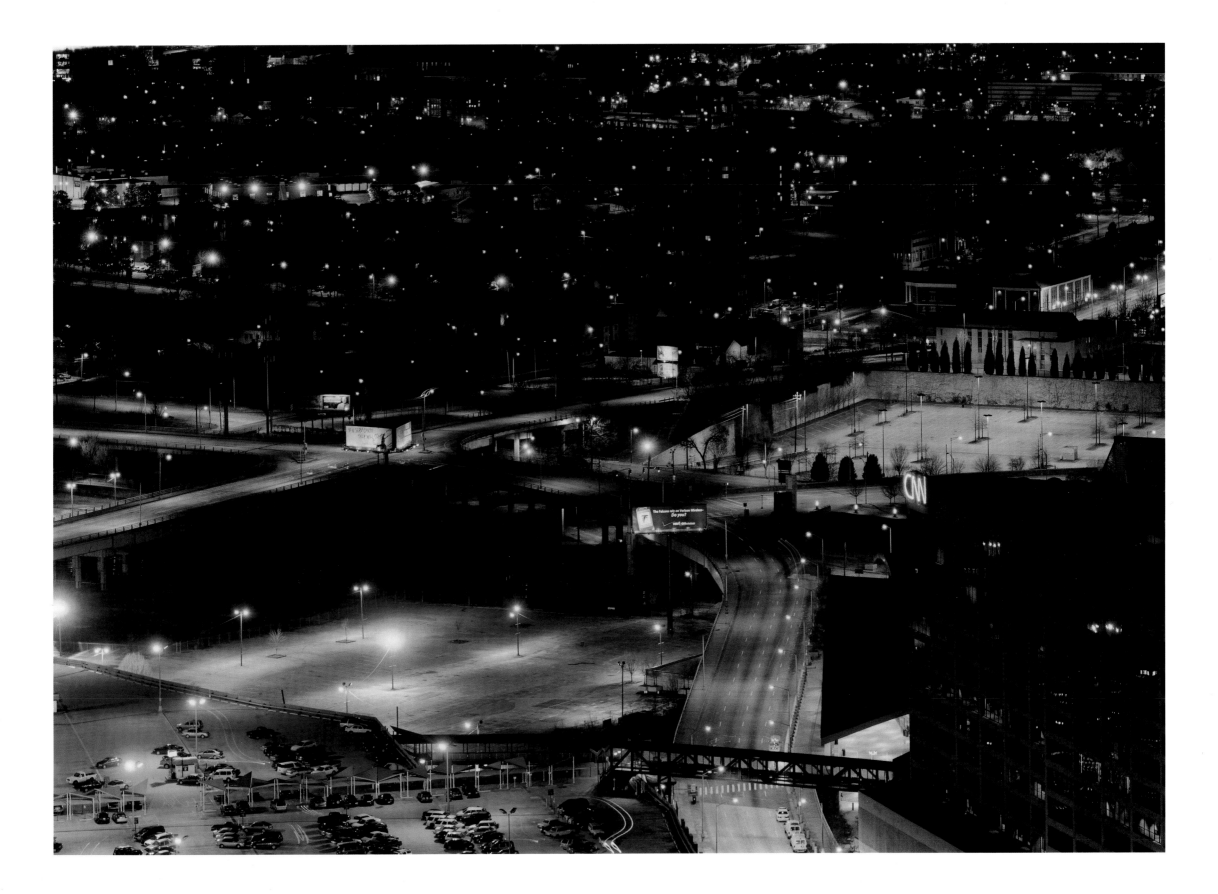

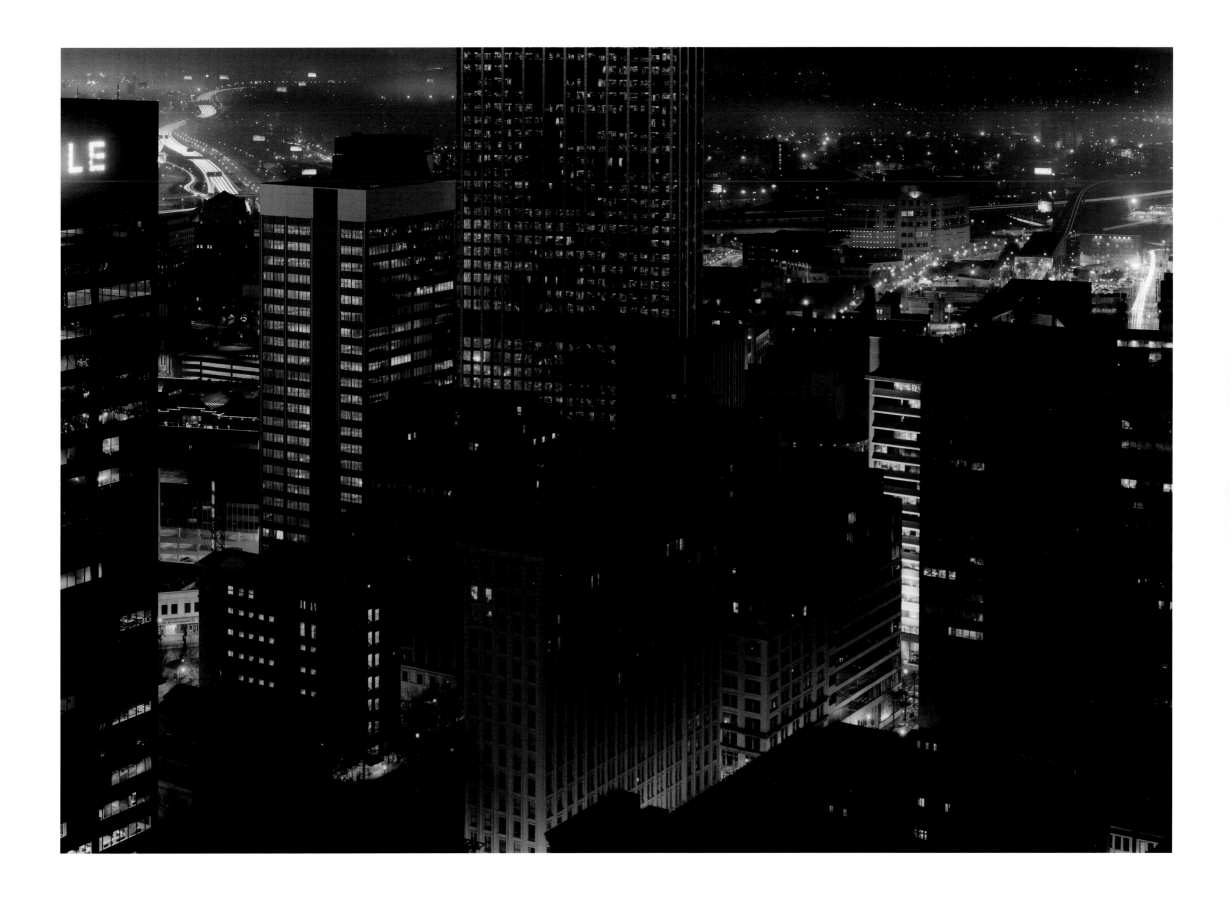

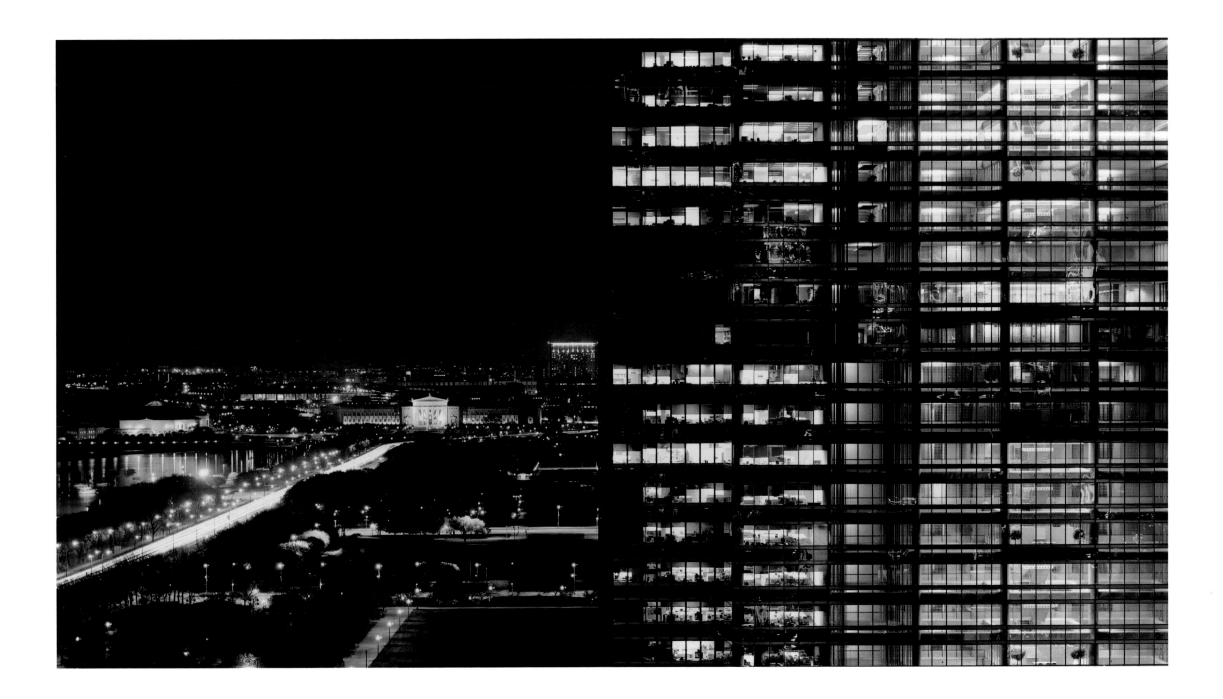

18 LAS VEGAS 2003

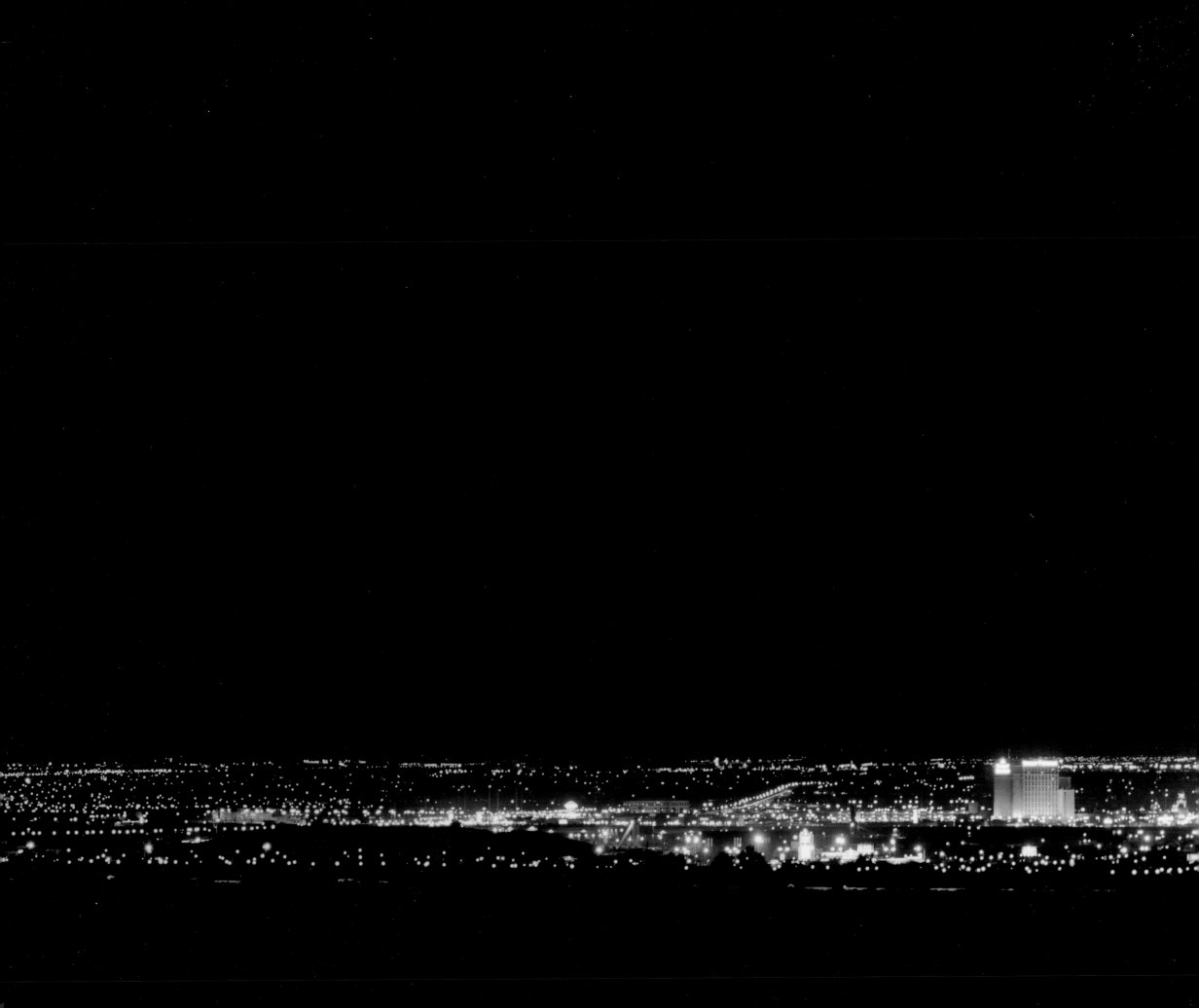

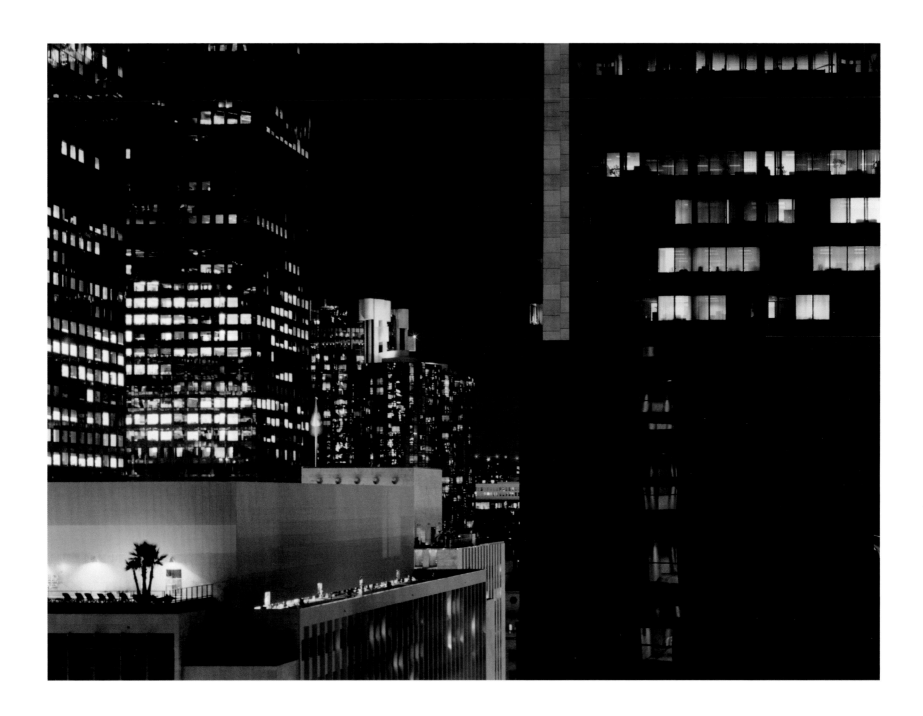

LAS VEGAS NEW YORK NEW YORK 2003

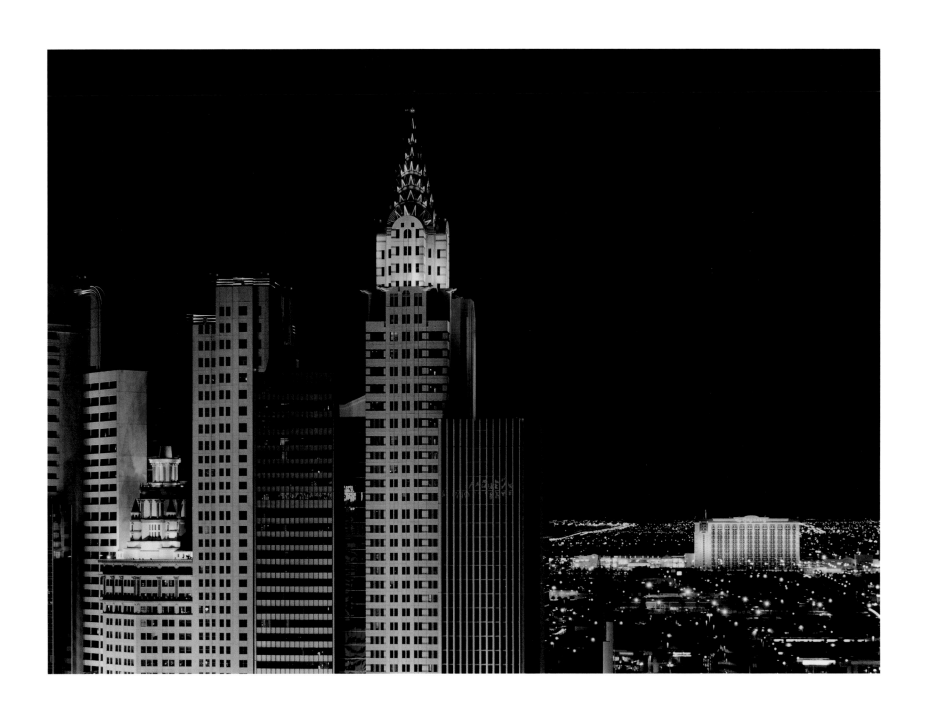

24 **LAS VEGAS** STRATOSPHERE TOWER 2003

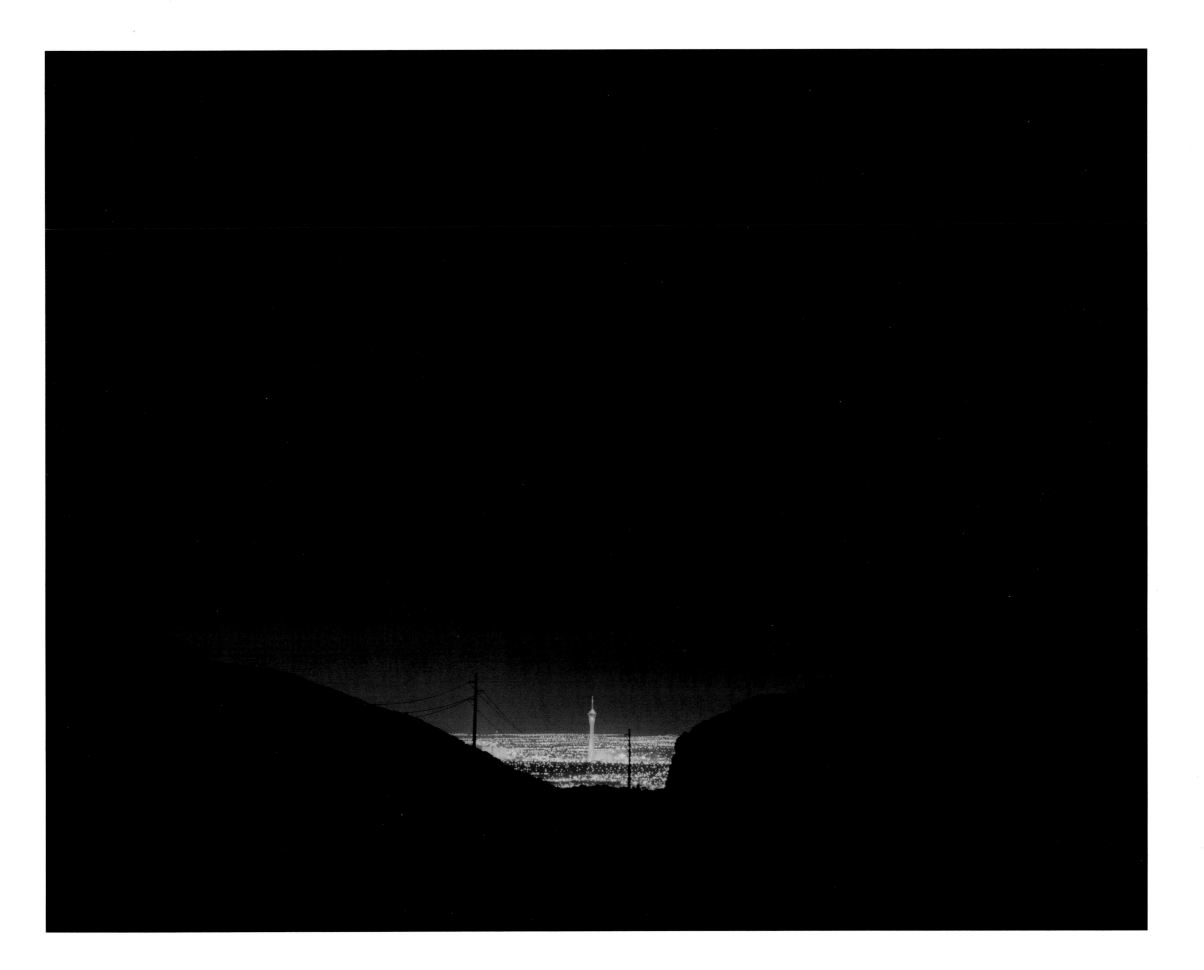

26 **LAS VEGAS** CAESARS PALACE 2003

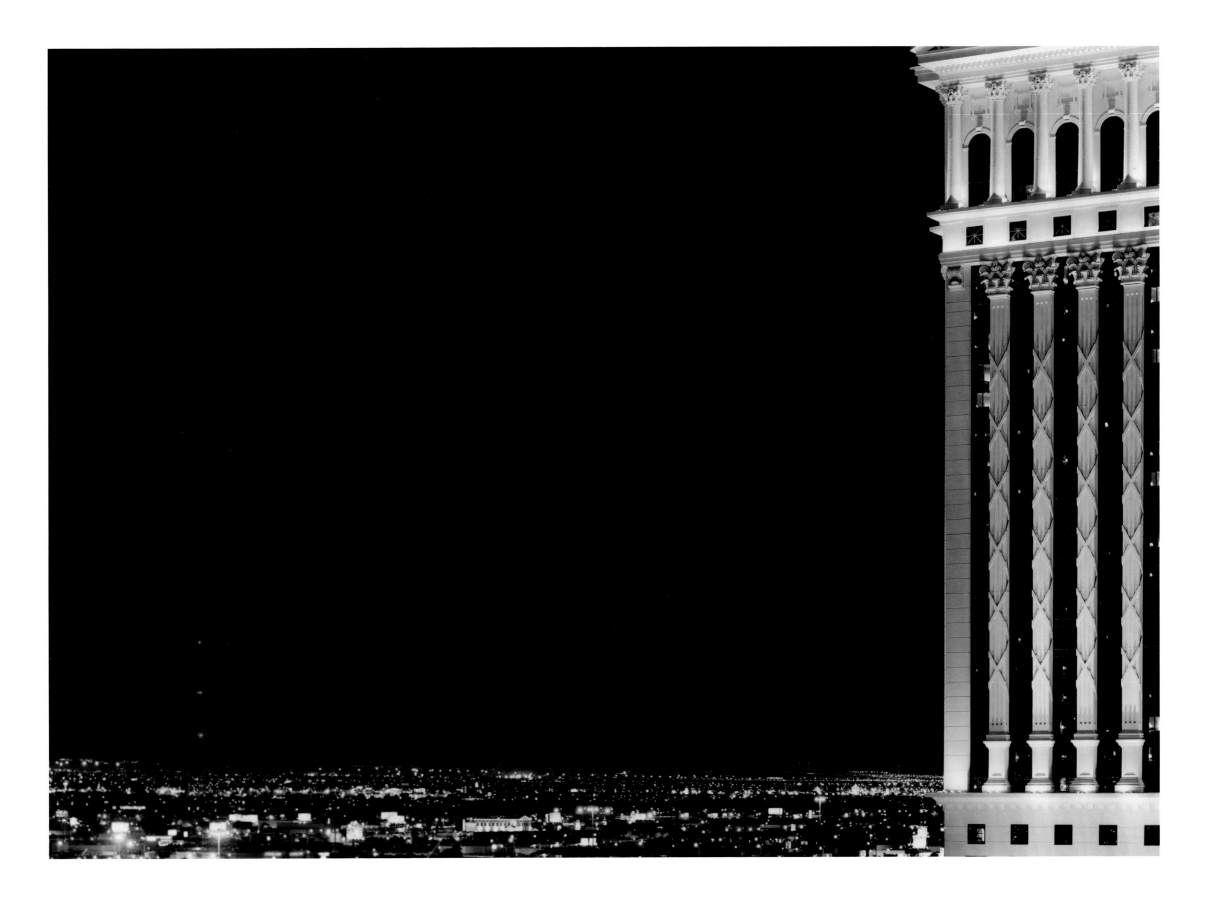

LAS VEGAS MANDALAY-I 2003

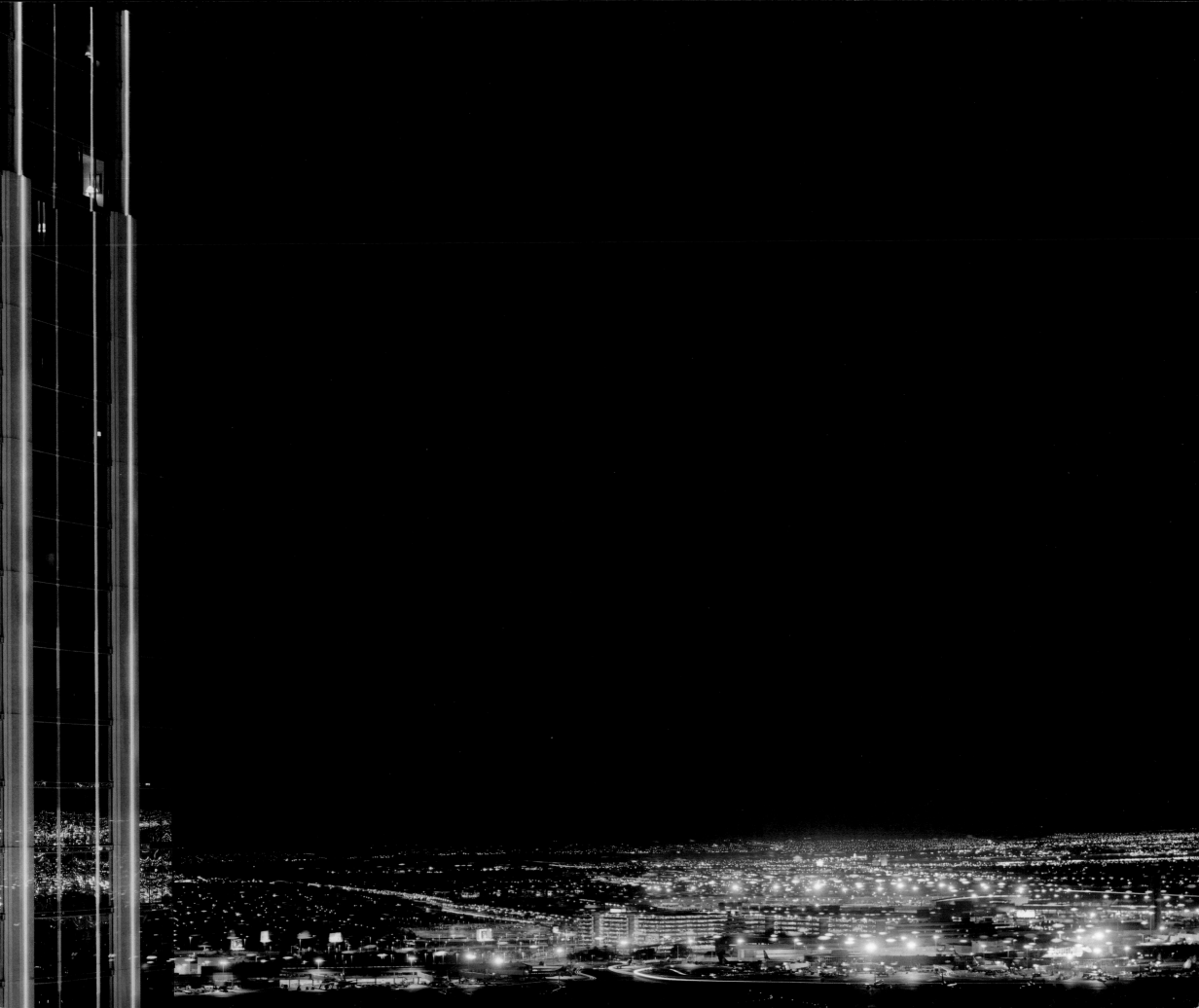

NEW YORK BRYANT PARK 2002

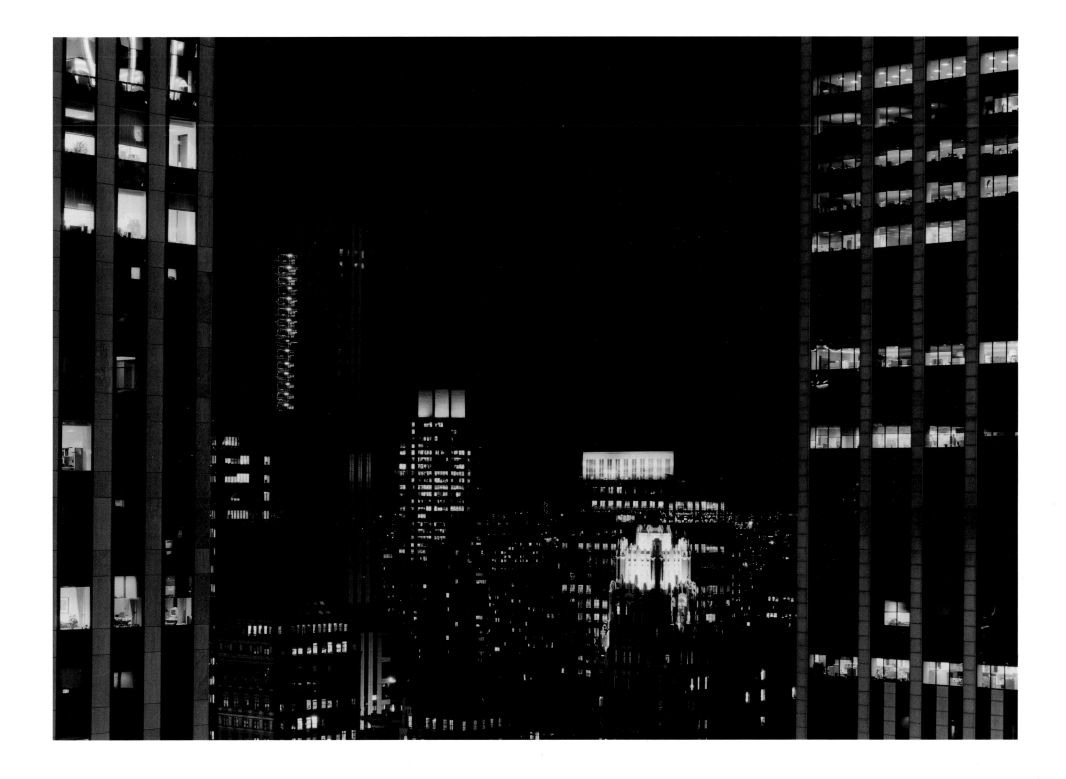

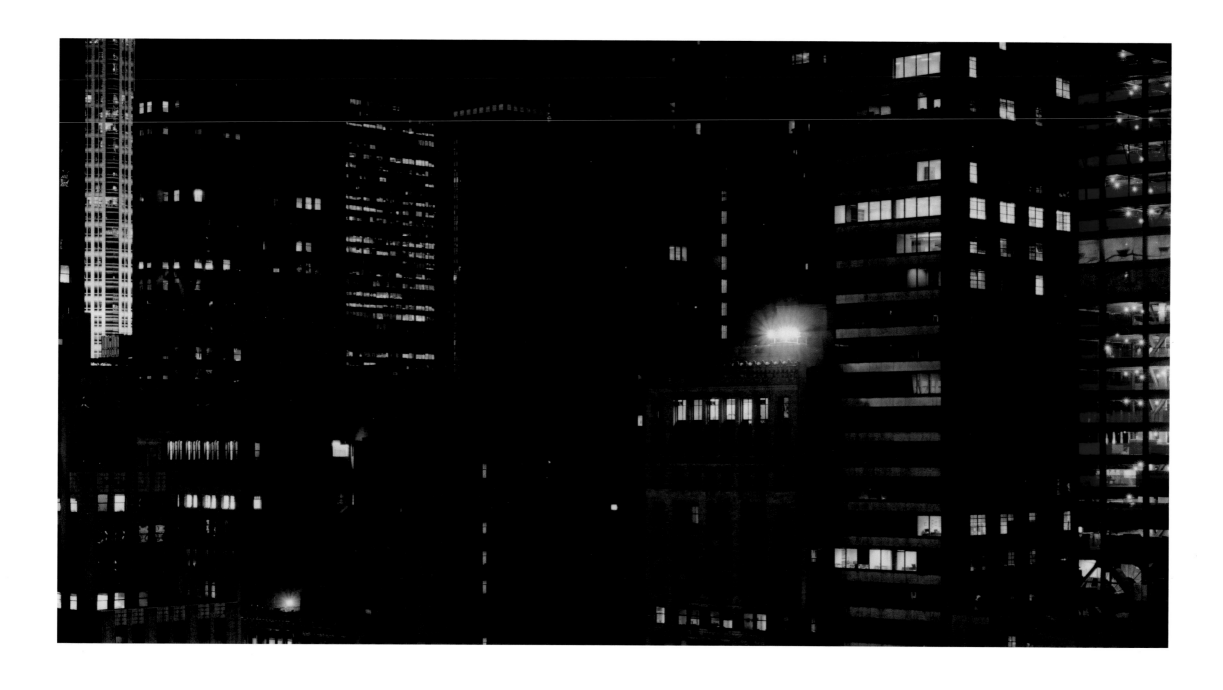

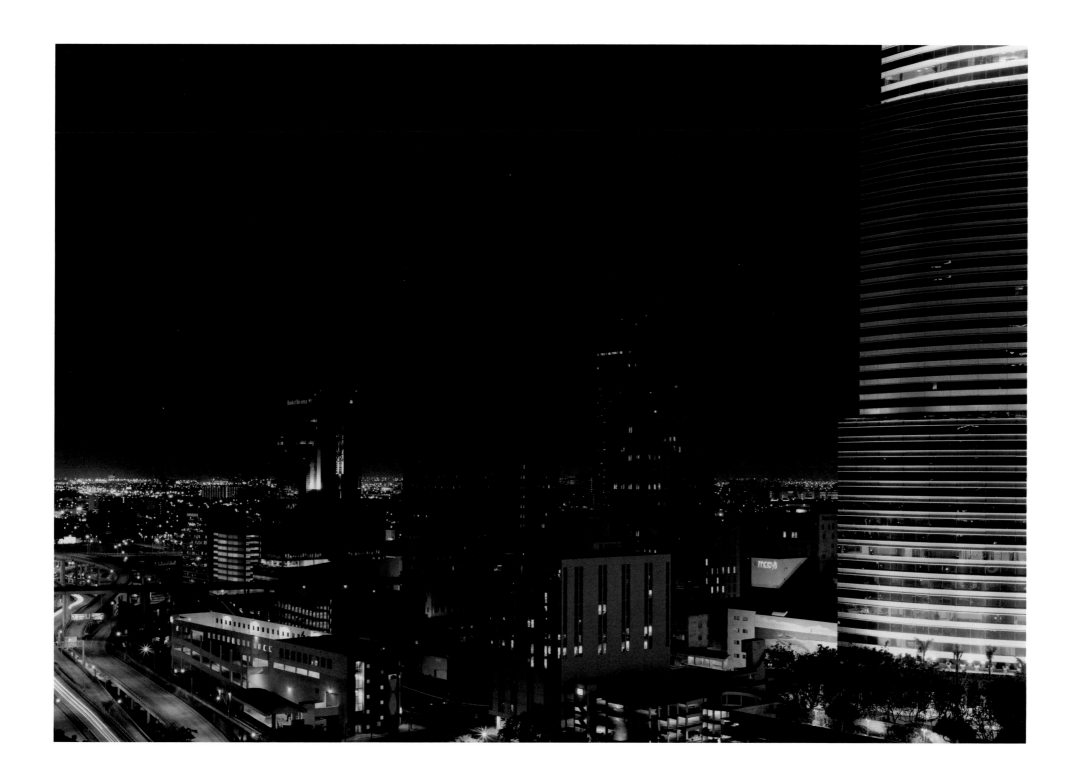

36 **MIAMI** FORTUNE HOTEL 2006

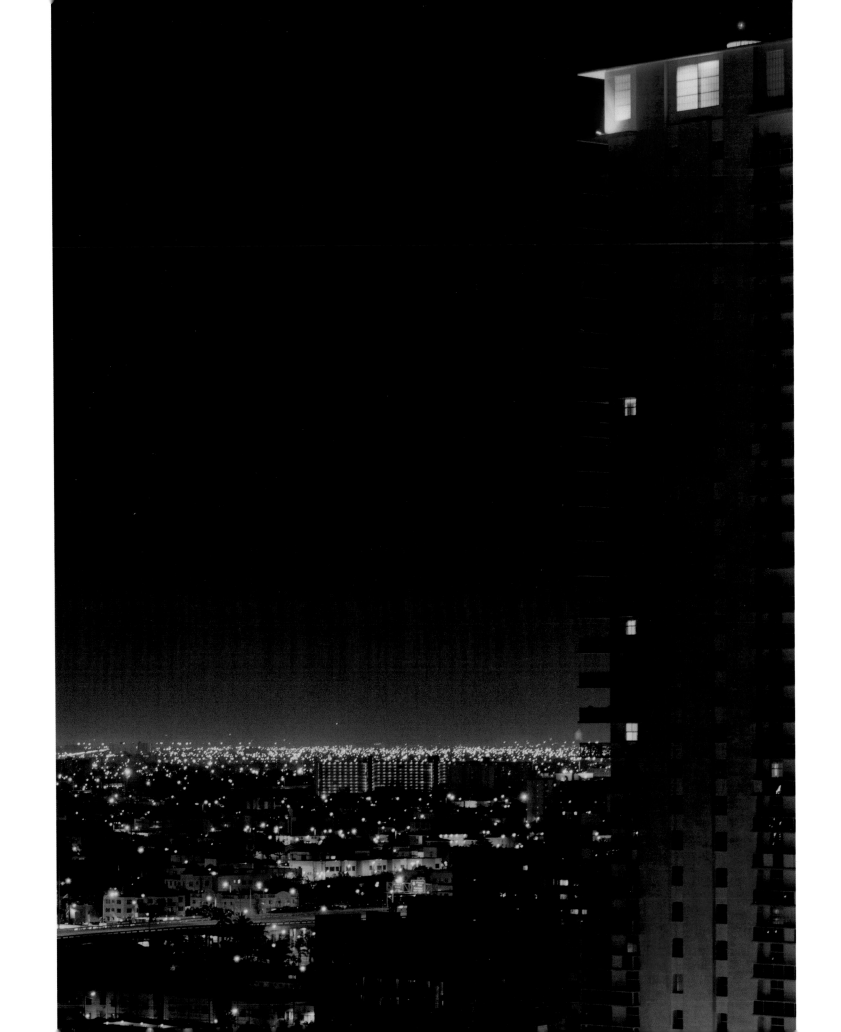

38 **MIAMI** RICKENBACKER CAUSEWAY 2006

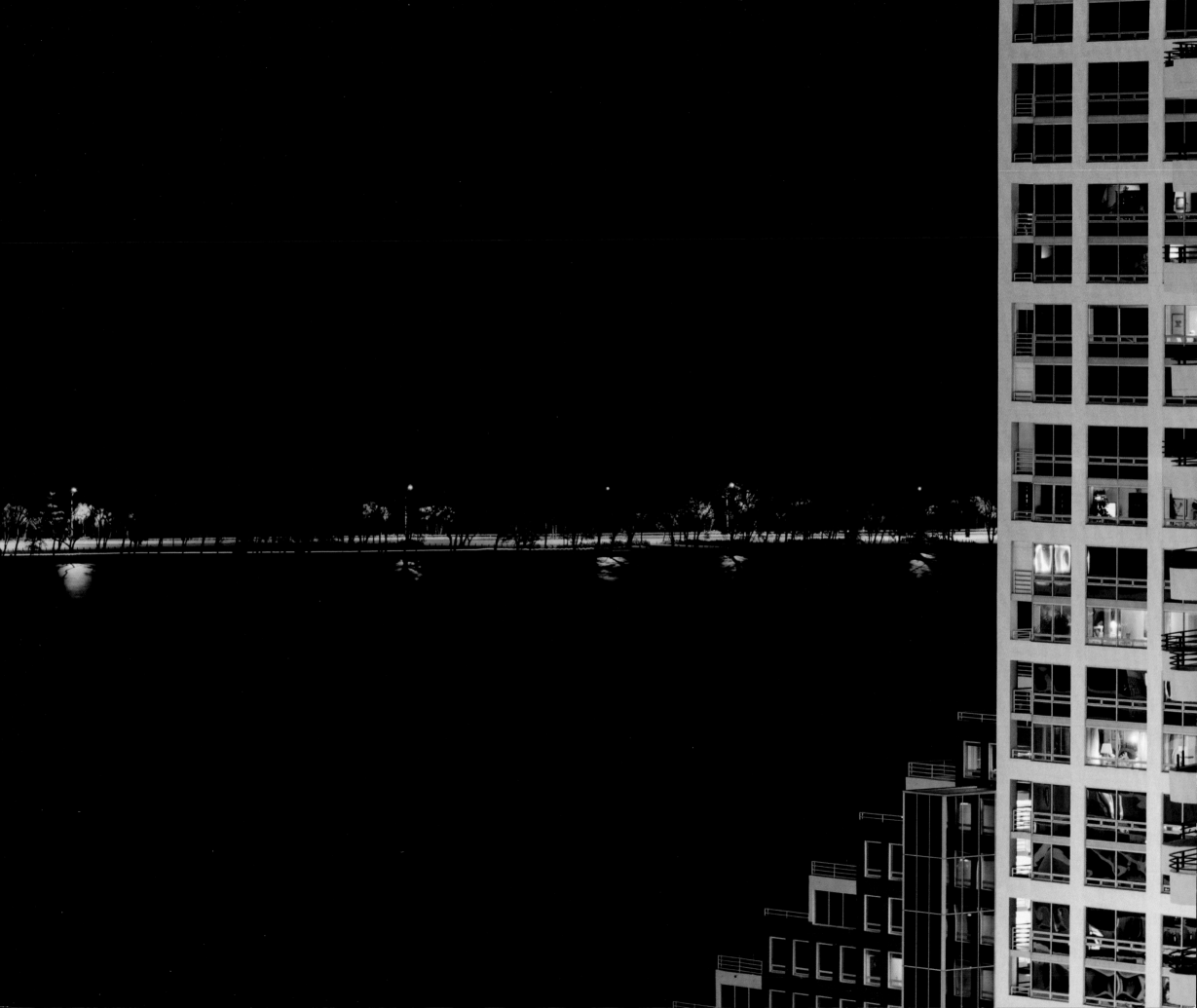

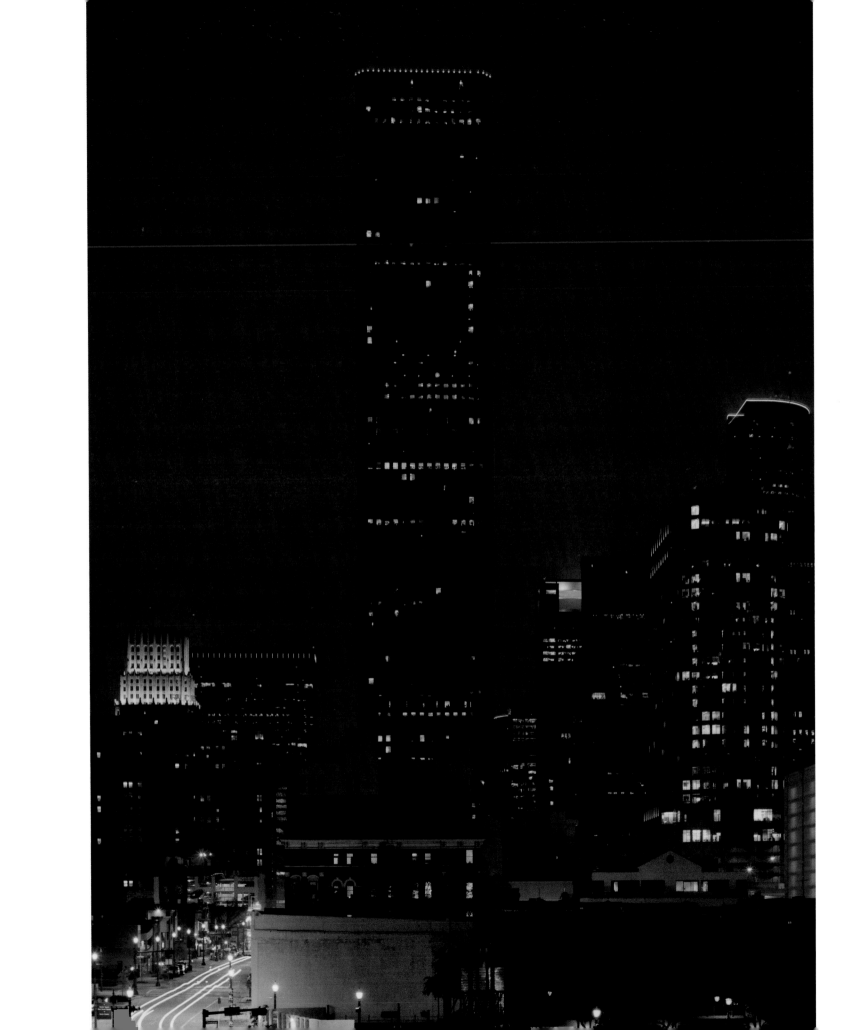

MINNEAPOLIS MISSISSIPPI 2006

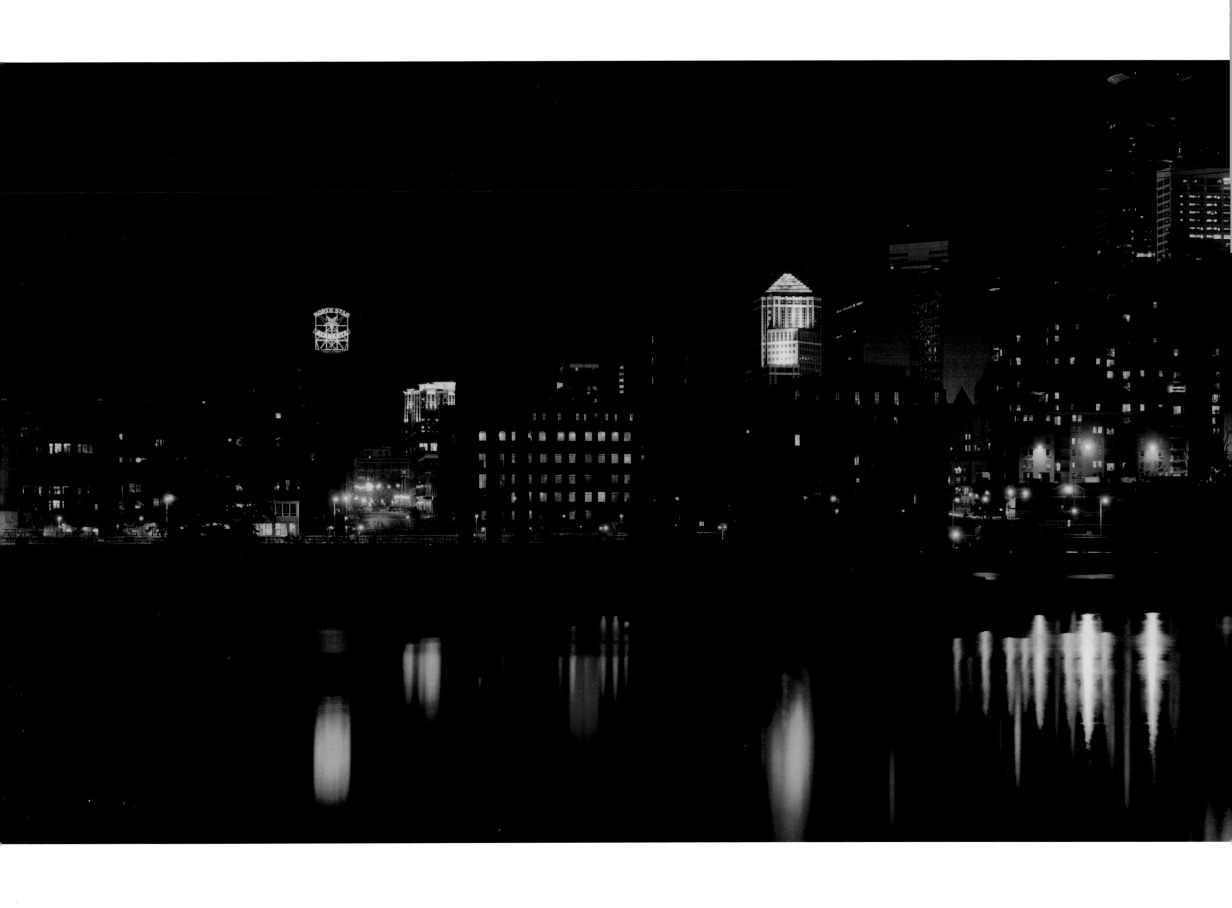

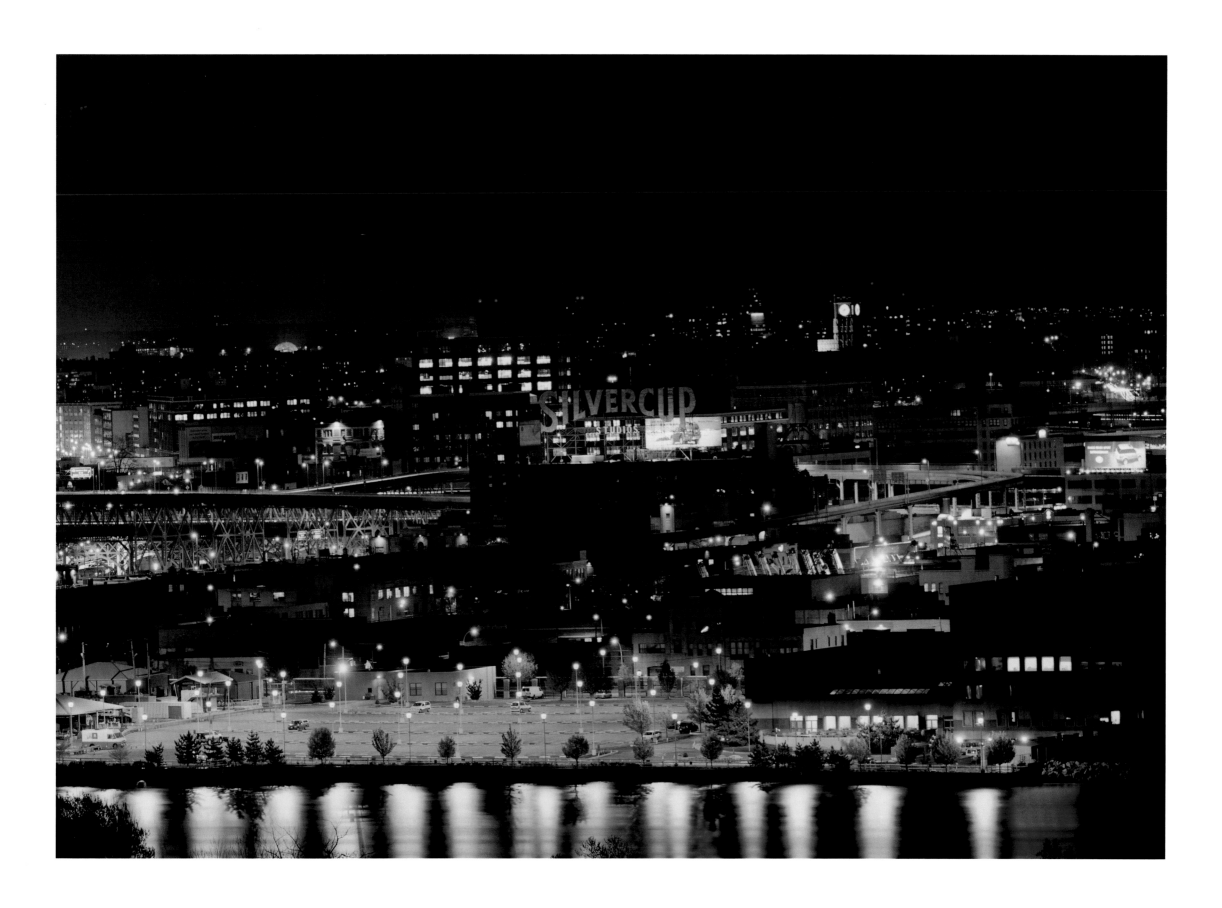

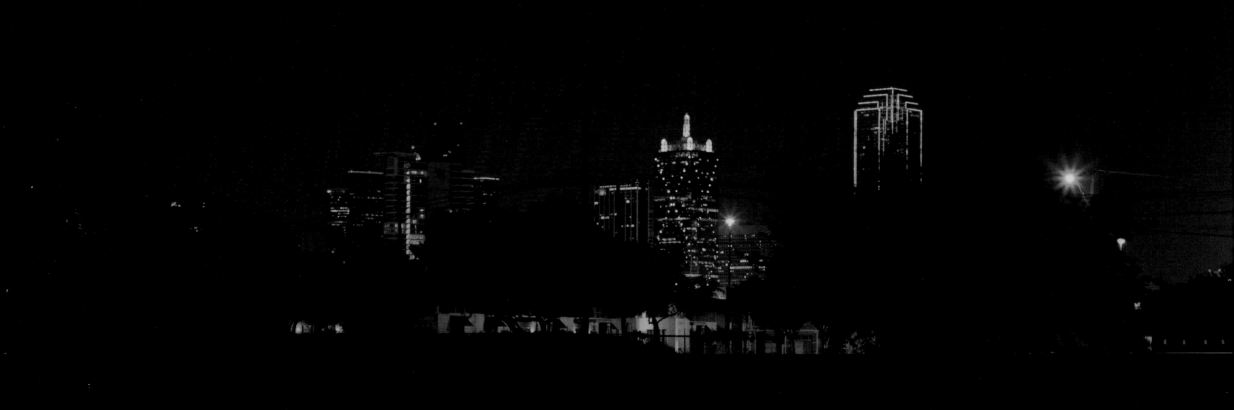

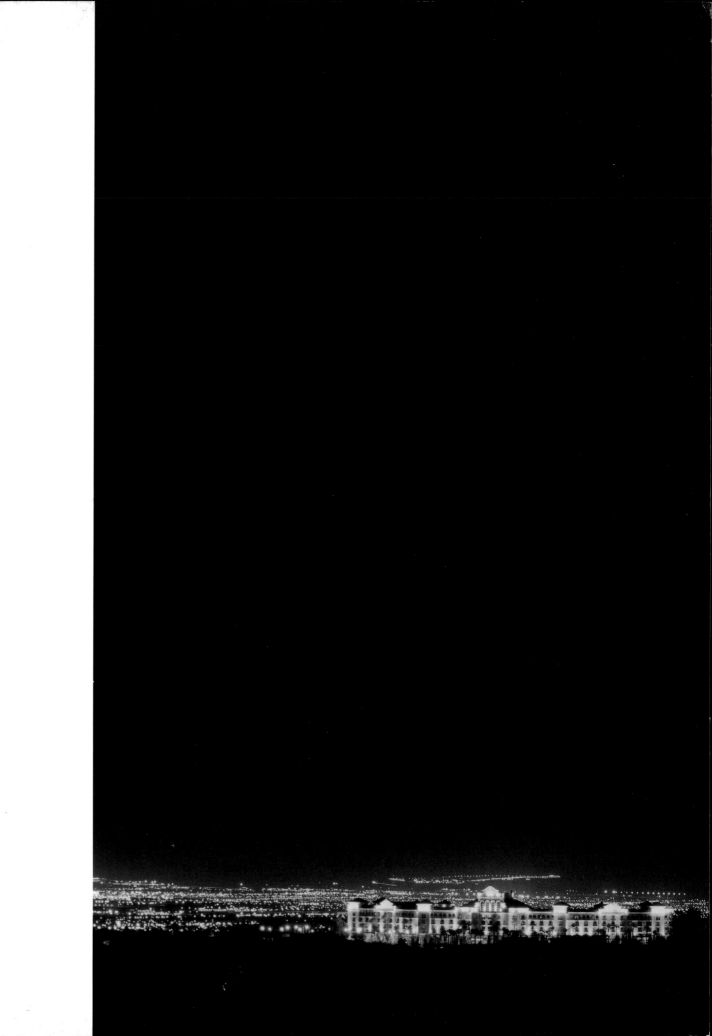

48 LAS VEGAS RAMPART 2003

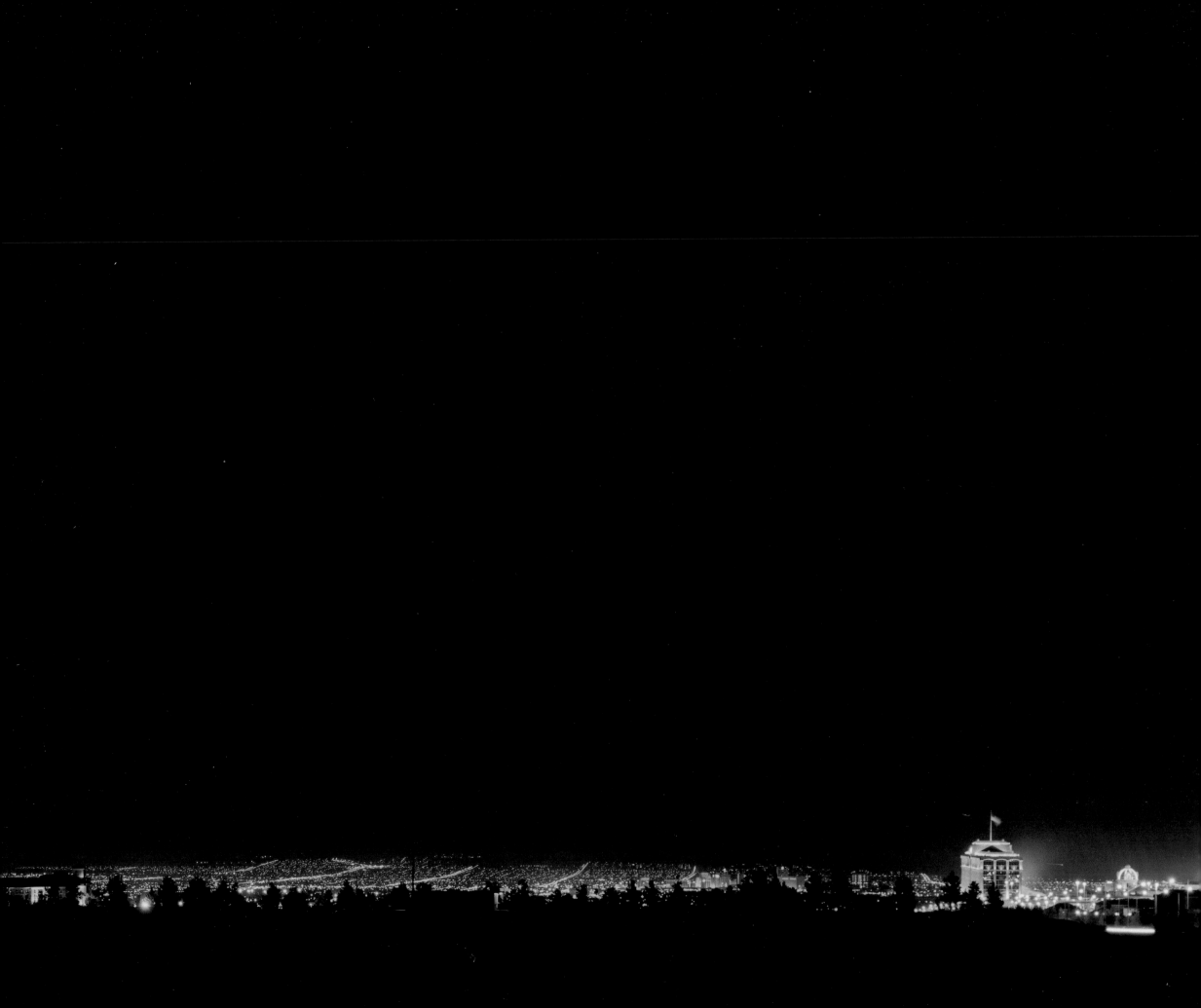

51 **SEATTLE** LIBRARY-II 2005

AFTER MIDNIGHT

LAS VEGAS

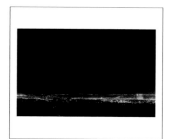

18 Las Vegas, 2003
61 3/4 x 93 1/4 in
157 x 237 cm

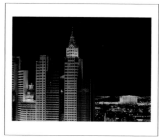

22 New York New York, 2003
45 1/4 x 57 1/8 in
115 x 145 cm

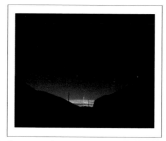

24 Stratosphere Tower, 2003
53 1/8 x 65 in
135 x 165 cm

LOS ANGELES

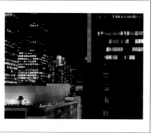

20 Standard Hotel, 2005
61 3/4 x 81 1/2 in
157 x 207 cm

NEW YORK

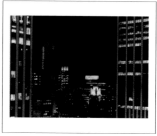

30 Bryant Park, 2002
57 7/8 x 73 5/8 in
147 x 187 cm

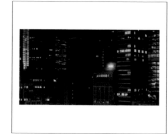

32 Pan Am, 2002
61 3/4 x 93 1/4 in
157 x 237 cm

HOUSTON

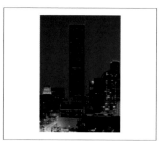

40 Rice, 2006
81 1/2 x 61 3/4 in
207 x 157 cm

MINNEAPOLIS

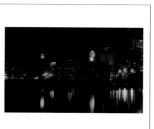

42 Mississippi, 2006
61 3/4 x 93 1/4 in
157 x 237 cm

ATLANTA

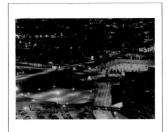

12 CNN, 2005
61 3/4 x 81 1/2 in
157 x 207 cm

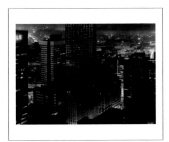

14 Equitable, 2005
49 1/4 x 61 in
125 x 155 cm

CHICAGO

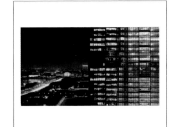

16 Field Museum, 2003
61 3/4 x 101 1/8 in
157 x 257 cm

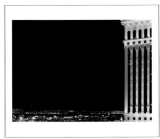

26 Caesars Palace, 2003
61 3/4 x 81 1/2 in
157 x 207 cm

28 Mandalay-I, 2003
61 3/4 x 81 1/2 in
157 x 207 cm

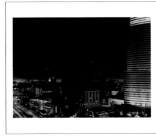

48 Rampart, 2003
61 3/4 x 93 1/4 in
157 x 237 cm

MIAMI

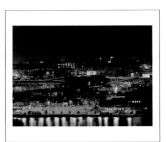

44 Silvercup, 2006
61 3/4 x 81 1/2 in
157 x 207 cm

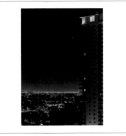

34 Bank of America, 2006
57 7/8 x 73 5/8 in
147 x 187 cm

36 Fortune Hotel, 2006
73 5/8 x 57 7/8 in
187 x 147 cm

38 Rickenbacker Causeway, 2006
61 3/4 x 73 5/8 in
157 x 187 cm

DALLAS

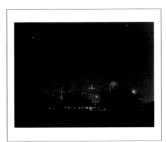

46 Dallas, 2006
57 7/8 x 73 5/8 in
147 x 187 cm

SEATTLE

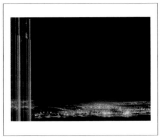

50 Library-I, 2005
55 7/8 x 122 in
142 x 310 cm

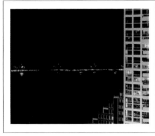

51 Library-II, 2005
55 7/8 x 122 in
142 x 310 cm

BIOGRAPHY

SOLO EXHIBITIONS
selection

GROUP EXHIBITIONS
selection

1951
born in Essen
lives and works in Düsseldorf
1973–81
studies at the Kunstakademie Düsseldorf
1982
DAAD-scholarship for London
1985
scholarship for the Deutsches Studienzentrum Venedig
1986–1988
Karl-Schmidt-Rottluff-scholarship
1993
Hermann Claasen Prize

2006
Henie Onstad Art Centre, Høvikodden, Norway
Galería Helga de Alvear, Madrid, Spain
Patricia Low Contemporary, Gstaad, Switzerland
Galeria Mário Sequeira, Braga, Portugal
Waddington Galleries, London, United Kingdom
2005
Galerie SixFriedrich/LisaUngar, Munich, Germany
Galerie Wilma Tolksdorf, Frankfurt a. M., Germany
2004
Reina Sofia, Palacio de Velázquez, M.N.C.A.R.S. Madrid, Spain
Fundacion Cesar Manrique, Lanzarote, Spain
2002
Galerie Akinci, Amsterdam, The Netherlands
Cohan Leslie and Browne Gallery, New York, USA
Galerie Max Hetzler, Berlin, Germany
Galleri K, Oslo, Norway
2001
Huis Marseille Foundation for Photography, Amsterdam, The Netherlands
Galerie Max Hetzler, Berlin, Germany
2000
Kontinente, Haus der Preussag AG, Hannover, Germany
Museum Kurhaus Kleve, Germany
Galería Helga de Alvear, Madrid, Spain

1999
Galerie Wilma Tolksdorf, Frankfurt a. M., Germany
Galeri K, Oslo, Norway
1998
Musée-Château d'Annecy, Annecy, France
Galerie Akinci, Amsterdam, The Netherlands
Galerie Max Hetzler, Berlin, Germany
1997
Patrick de Brock Gallery, Knokke, Belgium
Kunstverein Hannover, Germany
Fotomuseum Winterthur, Winterthur, Switzerland (cat.)
Musei Civici Rubiera, Reggio Emilia, Italy
1996
Kunstverein Wolfsburg, Wolfsburg, Germany
Galerie Laage-Salomon, Paris, France
1995
Rheinisches Landesmuseum, Bonn, Germany (cat.)
1993
Hamburger Kunsthalle, Hamburg, Germany (cat.)
Kunstraum München, Munich, Germany
Eleni Koroneu Gallery, Athens, Greece
1992
Museum Künstlerkolonie Darmstadt, Darmstadt, Germany (cat.)
Fonds régional d'art contemporain, Marseille, France (cat.)
Kunstraum München, Munich, Germany

1991
Galeries Bruges la Morte, Brügge, Belgium
1990
Galerie Laage-Salomon, Paris, France
Glenn & Dash Gallery, Los Angeles, USA
1989
Rotterdamse Kunsstichting, Rotterdam, The Netherlands
Regionalmuseum, Xanten, Germany (cat.)
1987
Actualites, London, United Kingdom
Galerie Max Hetzler, Köln, Germany
1984
Galerie Konrad Fischer, Düsseldorf, Germany

2005
Welt–Bilder / World Images
Helmhaus Zürich, Switzerland
2003
Miradas y conceptos en la colección Helga de Alvear,
Centro Cultural San Jorge, Cáceres, Spain
Ojective Spaces: Photographers from Germany,
Waddington Galleries, London, United Kingdom
2002
Heute bis jetzt
Museum Kunst Palast, Düsseldorf, Germany
Paisajes Contemporáneos Colección Helga de Alvear
Fundación Colectania, Barcelona, Spain
In Szene gesetzt
ZKM, Karlsruhe, Germany
2001
Nature in Photography
Galerie Nächst St. Stephan Rosemarie Schwarzwälder, Vienna, Austria
2000
Ansicht / Aussicht / Einsicht – Architekturphotographie
Museum Bochum, Bochum, Germany / Galerie für Zeitgenössische Kunst, Leipzig, Germany
How you look at it – Photographien des 20. Jahrhunderts
Sprengel Museum, Hannover, Germany

54

MONOGRAPHS

1998
Fotografía Paisajes
Galeria Heinrich Erhardt, Madrid,
Spain
Plain Air
Barbara Gladstone
Gallery, New York, USA
Landschaft – Die Spur des Sublimen
Kunsthalle Kiel, Kiel, Germany
La Sentiment de la Montagne
Musée de Grenoble, Grenoble, France
*At the End of the Century –
100 Years of Architecture*
Museum of Contemporary Art, Tokyo,
Japan / Museum Ludwig, Köln,
Germany / Museum of
Contemporary Art, Los Angeles, USA /
Solomon R. Guggenheim Museum,
New York, USA
1997
Die Schwerkraft der Berge
Aargauer Kunsthaus, Aarau,
Switzerland / Kunsthalle Krems,
Krems, Austria
*Alpenblick – Die zeitgenössische
Kunst und das Alpine*
Kunsthalle Wien, Vienna, Austria
Landschaften Landscapes
Kunstverein für die Rheinlande und
Westfalen, Düsseldorf, Germany

1994
*Deutsche Kunst mit Photographie:
Die 90er Jahre*
Rheinisches Landesmuseum, Bonn,
Germany / Kunstverein
Wolfsburg, Wolfsburg, Germany
*Junge deutsche Kunst
der 90er Jahre aus NRW*
Museum of Art, Osaka, Japan /
Sonje Museum of Contemporary Art,
Kyonju, Korea / Pao Galleries
Hong Kong Arts Centre,
Hong Kong, China / Taipei
Fine Arts Museum, Taipei, Taiwan
La Ville
Centre Georges Pompidou, Paris,
France
1993
Industriefotografie heute,
Sprengel Museum, Hannover,
Germany / Neue Pinakothek,
Munich, Germany
1992
Distanz und Nähe
Nationalgalerie, Berlin, Germany
1991
Museum of Contemporary
Photography New York, USA
Aus der Distanz
Kunstsammlung NRW,
Düsseldorf, Germany
Gedachten Gangen, Gedanken Gänge
Museum Fridericianum, Kassel,
Germany

1990
Der klare Blick
Kunstverein München, Munich,
Germany
Karl-Schmidt-Rottluff-Stipendium 6,
Städtische Kunsthalle Düsseldorf,
Germany
1988
*Binationale – Deutsche Kunst der
späten 80er Jahre/ German Art of
the Late 80´s*
Kunstsammlung NRW / Kunsthalle
Düsseldorf / Kunstverein für die
Rheinlande und Westfalen,
Düsseldorf, Germany / The Institute of
Contemporary Art, Museum of Fine
Arts, Boston, USA

*Einsichten – Aussichten. 4 Aspekte
subjektiver Dokumentarfotografie*
Städtische Galerie Regensburg,
Germany
1982
Lichtbildnisse
Rheinisches Landesmuseum, Bonn,
Germany
1979
In Deutschland
Rheinisches Landesmuseum, Bonn,
Germany

*Axel Hütte / 1981–1988 –
Architektur: Berlin, London,
Paris, Venezia, Xanten*
Regionalmuseum Xanten,
text by Veit Loers, Xanten 1988

*Axel Hütte / London –
Photographien 1982–1984*
Museum Künstlerkolonie
Darmstadt, text by Gerda Breuer,
Munich, 1992

Axel Hütte / Transit Berlin
Fonds régional d' art
contemporain, Marseille, 1992

*Axel Hütte / Italien–
Photographien*
Hamburger Kunsthalle, text by
Uwe M. Schneede, Munich, 1993

Axel Hütte / Landschaft
Rheinisches Landesmuseum Bonn,
texts by Klaus Honnef
and Veit Loers, Munich

Axel Hütte / Theorea
Fotomuseum Winterthur,
texts by Urs Stahel and
Hans Irrek, Munich 1996

Axel Hütte / Terre dei Canossa
Musei Civici Rubiera,
text by Hans Irrek,
Reggio Emilia 1997

Axel Hütte / Kontinente
Preussag AG Hannover,
text by Cees Nooteboom,
Munich, 2000

Axel Hütte / As Dark as Light
Huis Marseille, Amsterdam,
texts by Els Barents and Rudolf
Schmitz 2001

*Axel Hütte / Secret Garden,
Misty Mountain*
Galerie Max Hetzler, Berlin
Holzwarth Publication,
Berlin 2002

Axel Hütte / Terra Incognita
texts by Julio Llamazares
and Rosa Olivares,
Museo Nacional Centro de Arte Reina
Sofia, Fundación César
Manrique, Lanzarote, Spain
Munich, 2004

Axel Hütte / North/South
text by Hanne Holm-Johnsen
Henie Onstad Art Centre,
Høvikodden, Norway, 2006

This book is published in
connection with the exhibition
After Midnight: Axel Hütte

Waddington Galleries,
London, United Kingdom,
4—28th October 2006

Dieses Buch erscheint anläßlich
der Ausstellung
After Midnight: Axel Hütte

Waddington Galleries, London,
4.—28. Oktober 2006

DRUCK/PRINTING

EBS, Verona

LITHOS

NovaConcept, Berlin

Schirmer/Mosel Production
www.schirmer-mosel.com

ISBN 3-8296-0261-8
978-3-8296-0261-7

JUL 26 2007